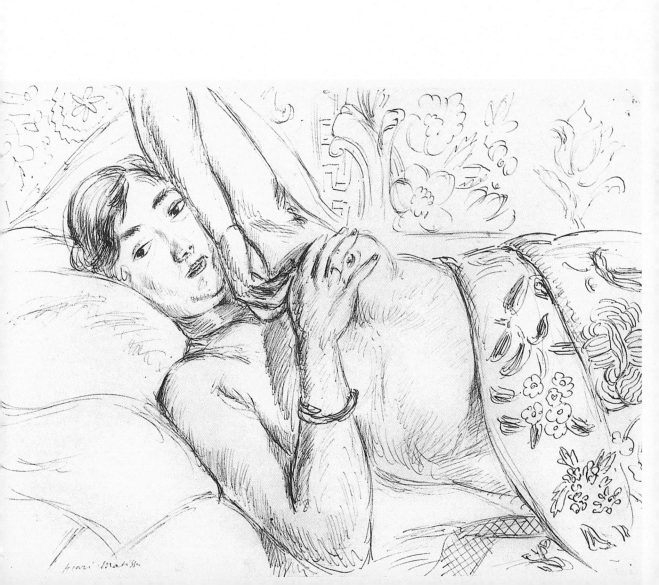

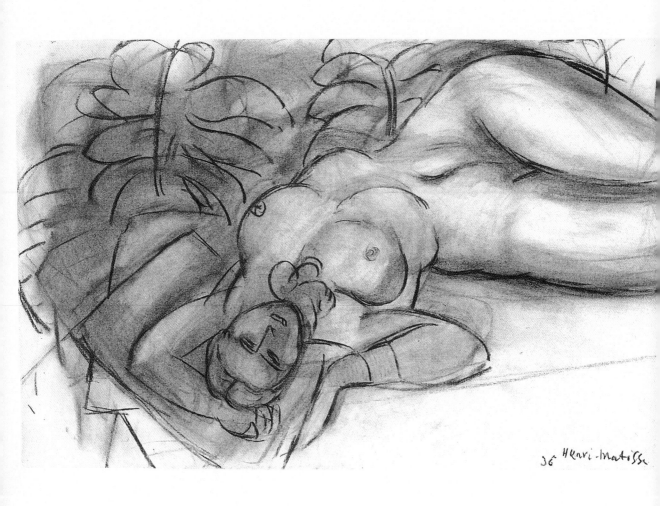

Erotic Sketches
Erotische Skizzen

HENRI MATISSE

Prestel

Munich · Berlin · London · New York

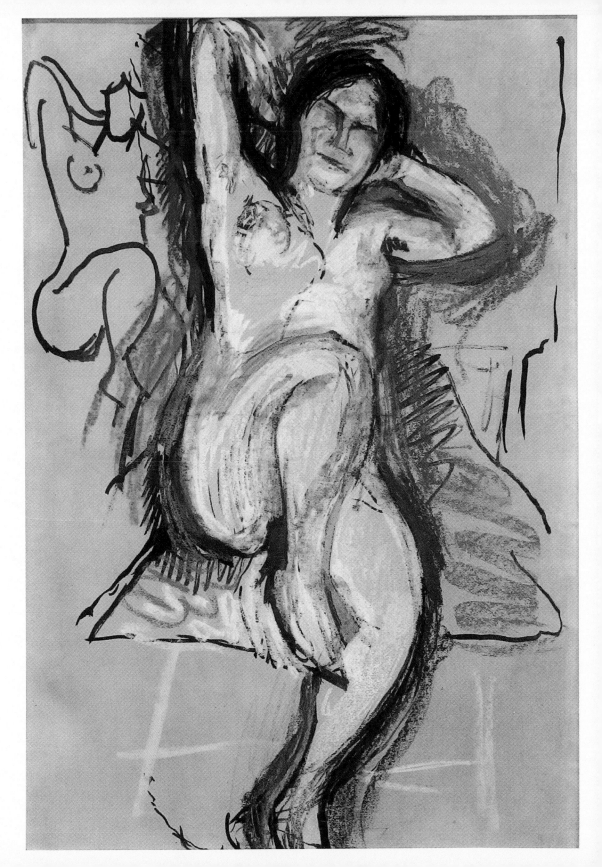

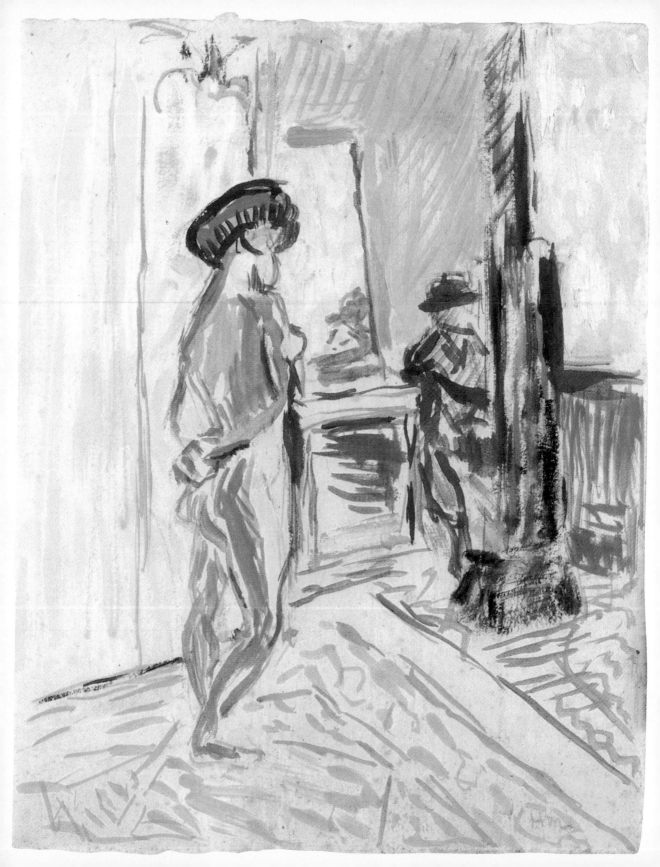

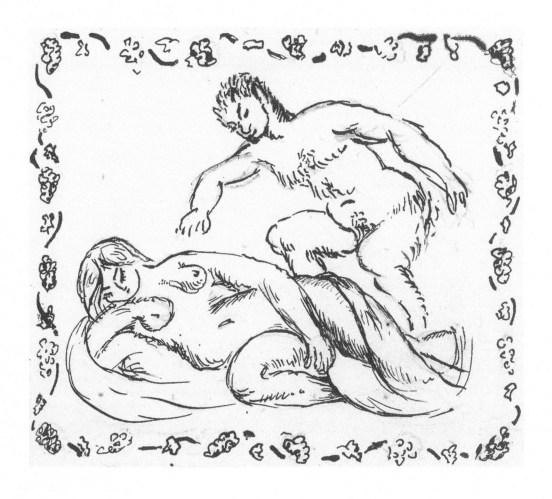

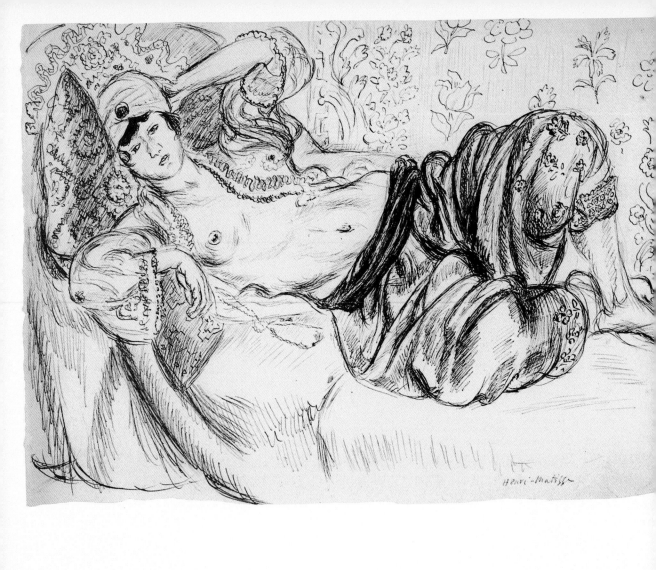

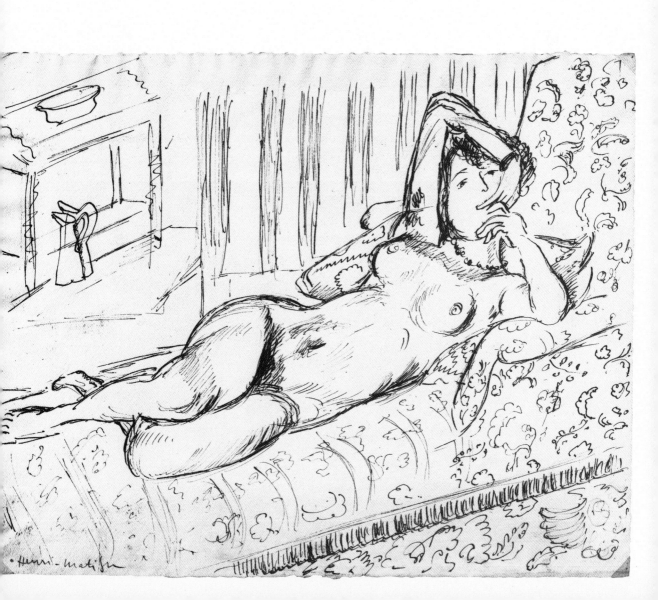

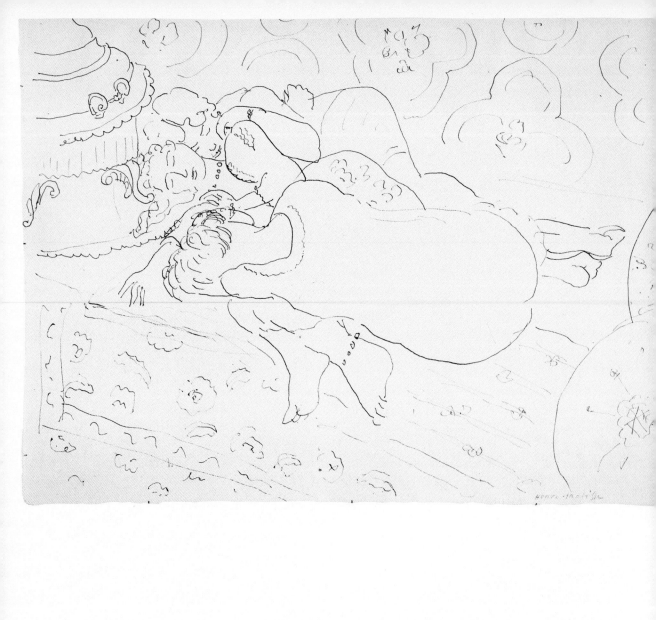

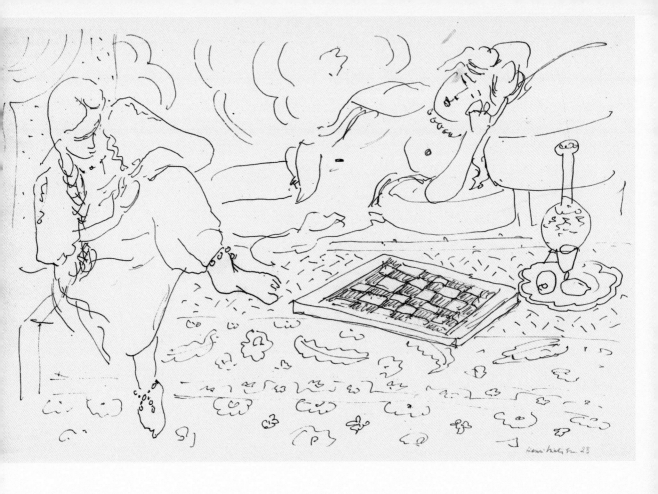

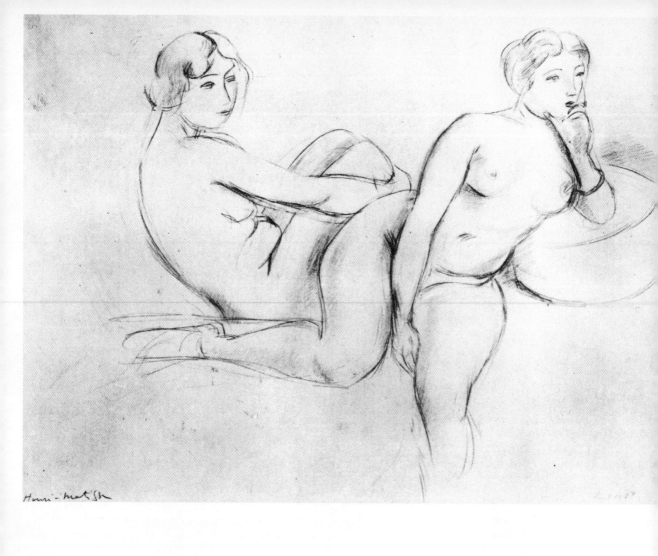

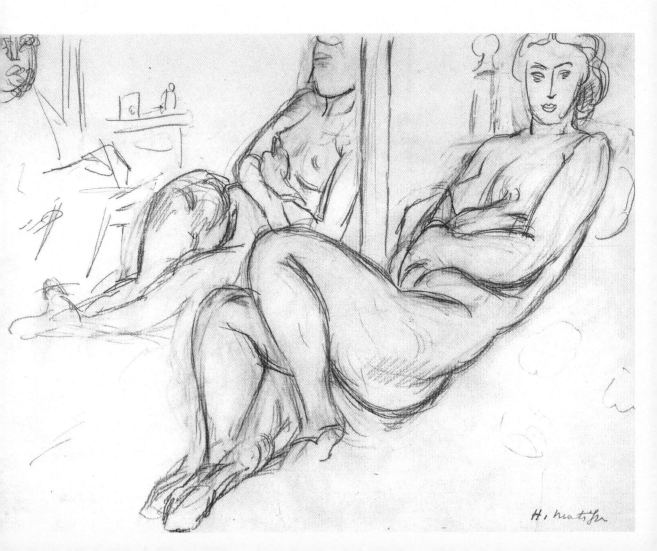

H. Matisse

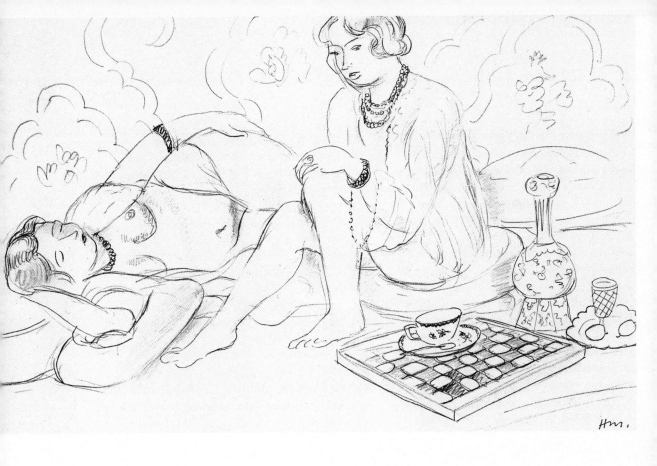

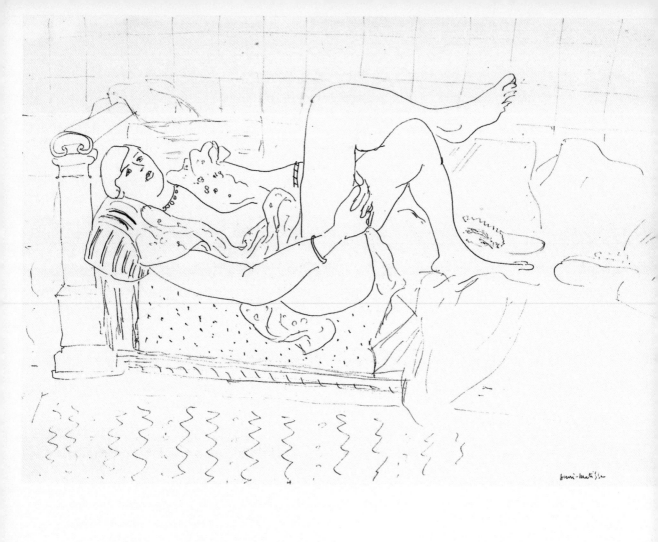

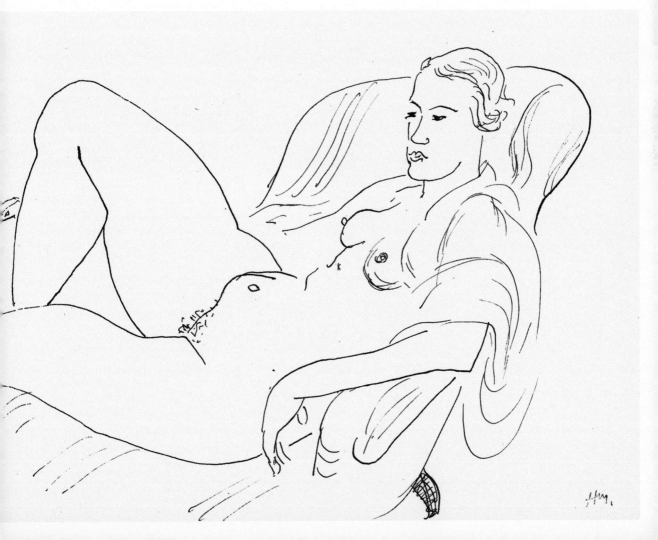

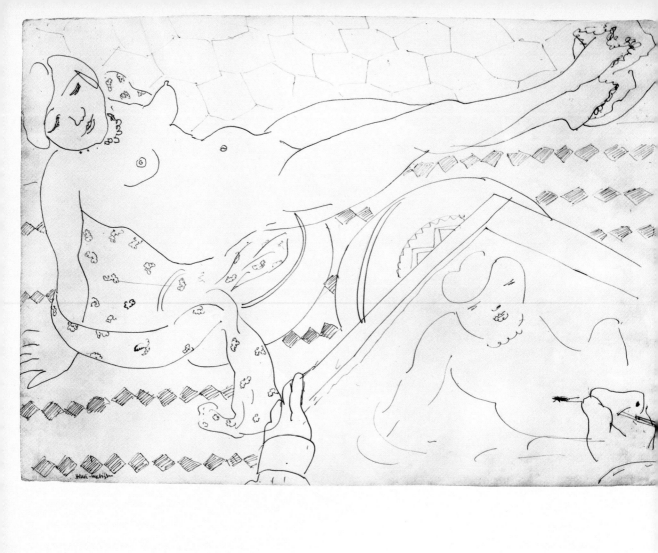

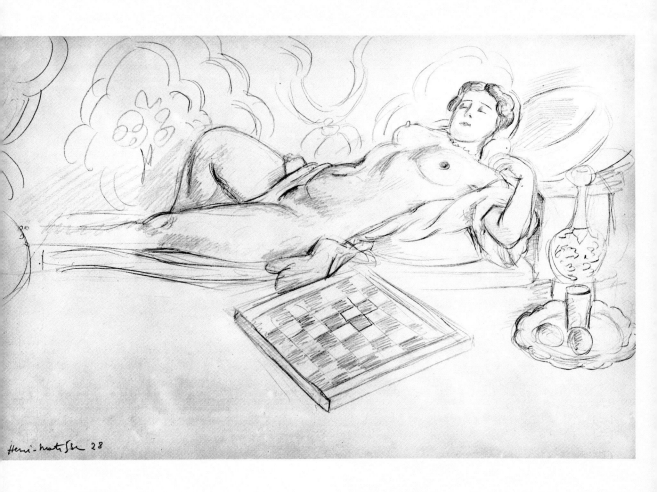

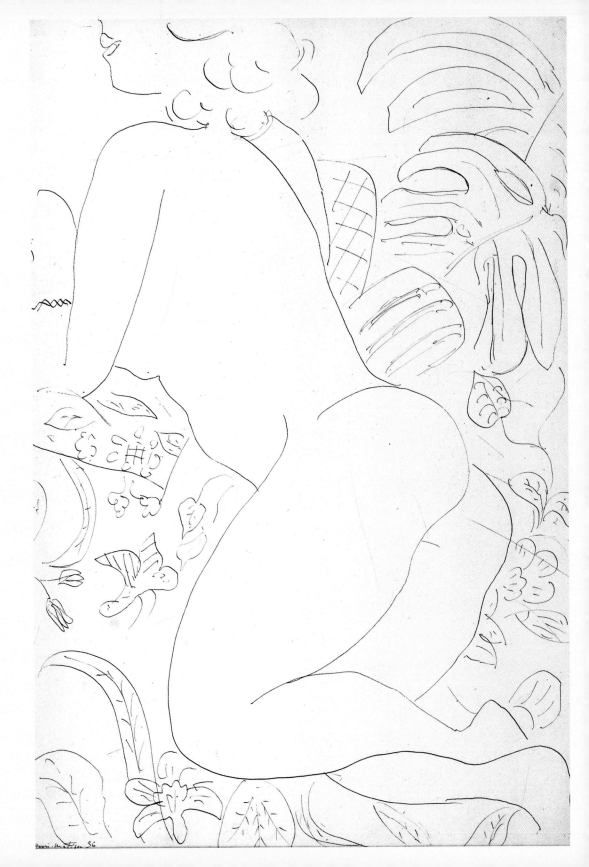

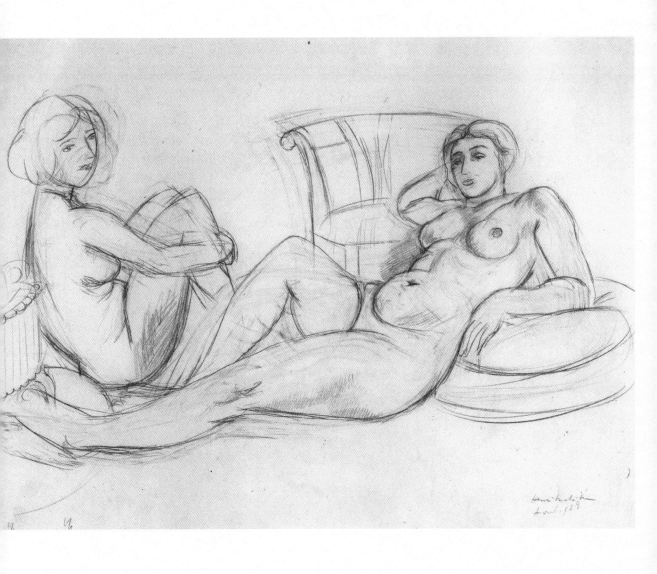

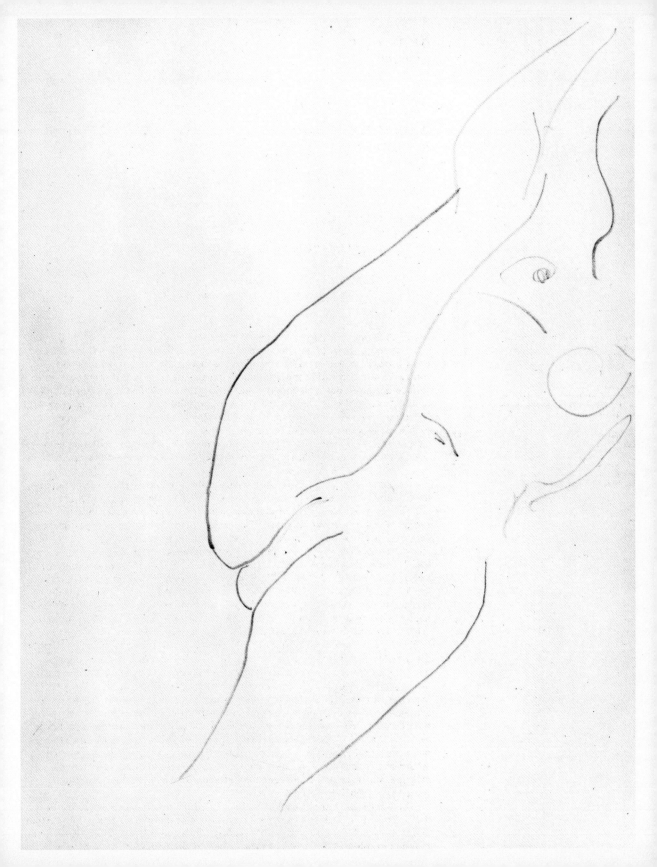

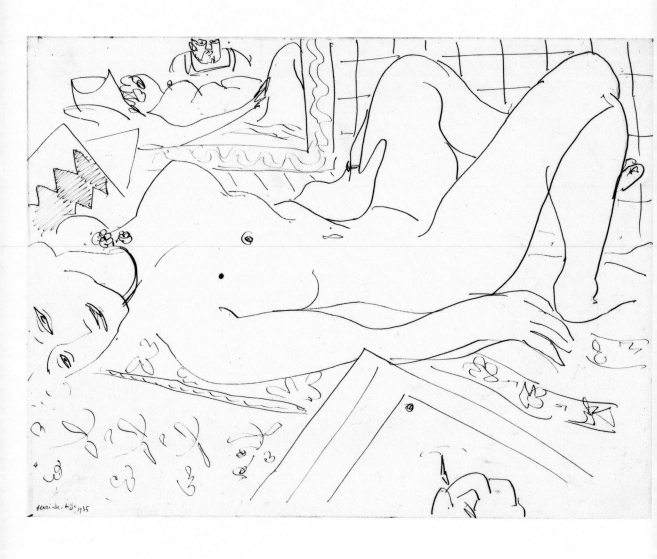

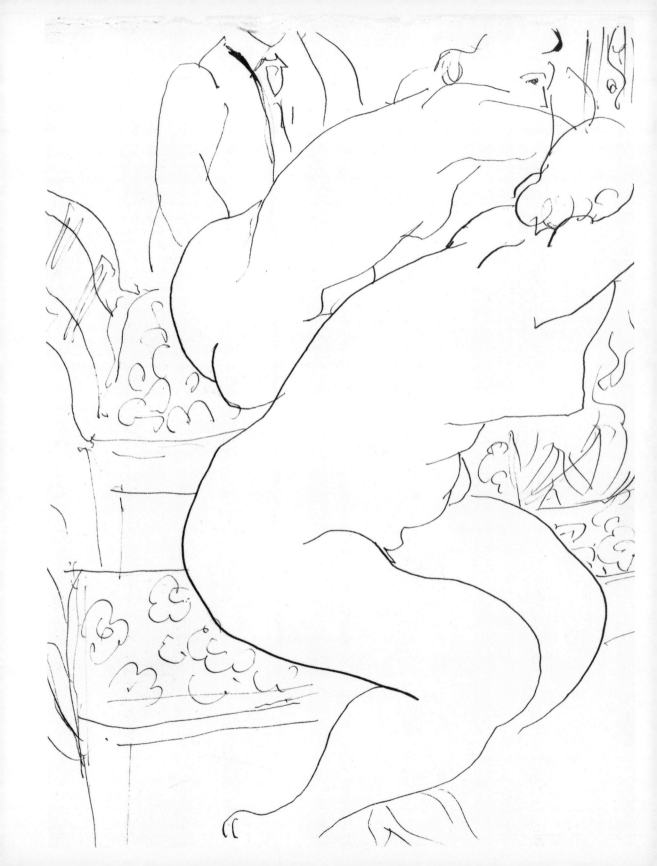

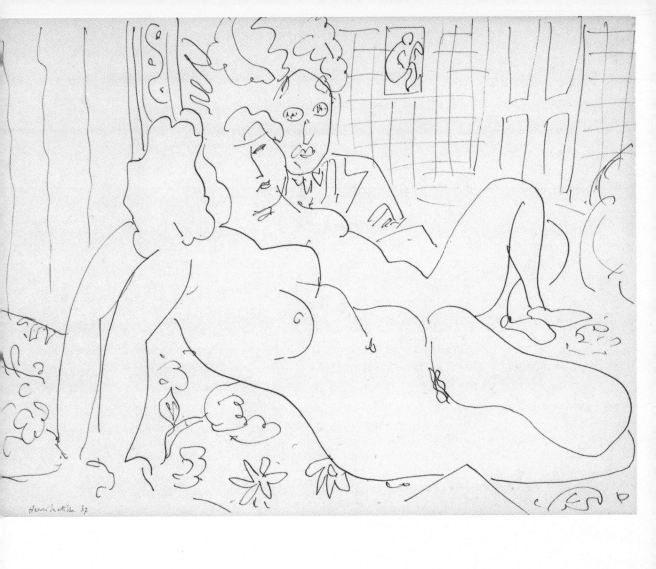

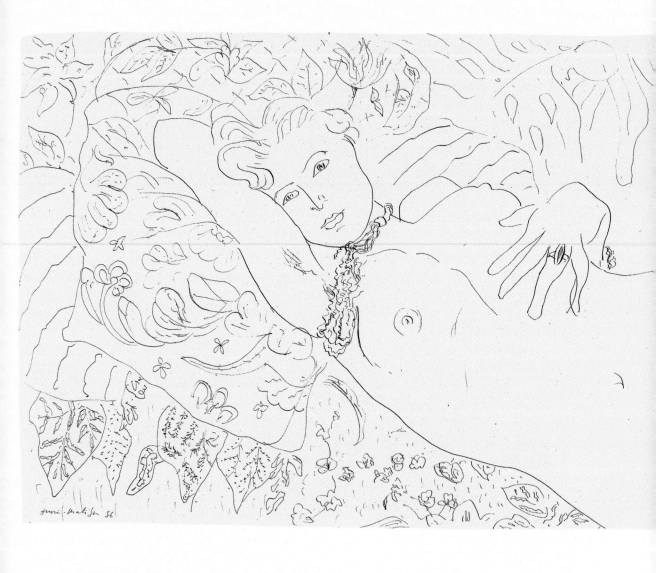

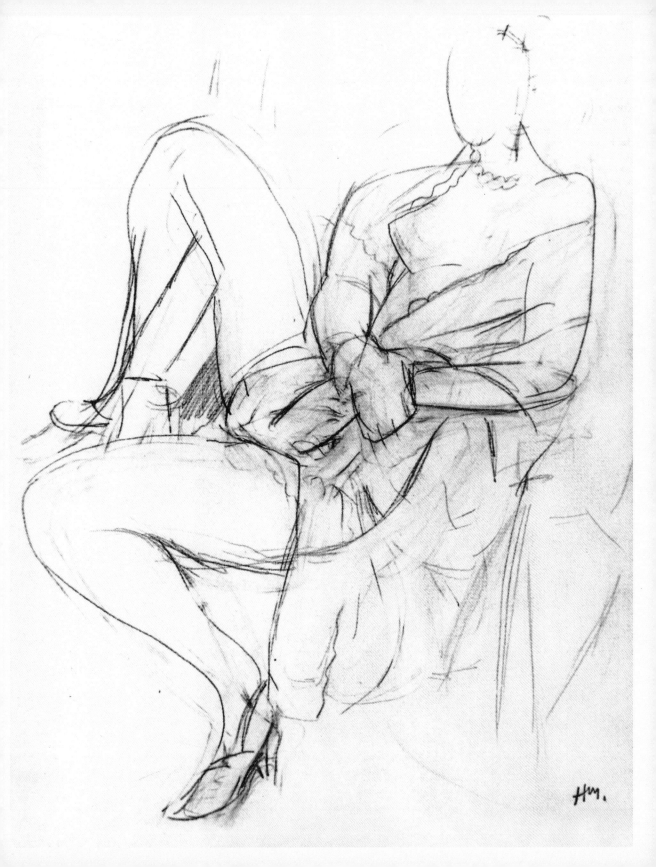

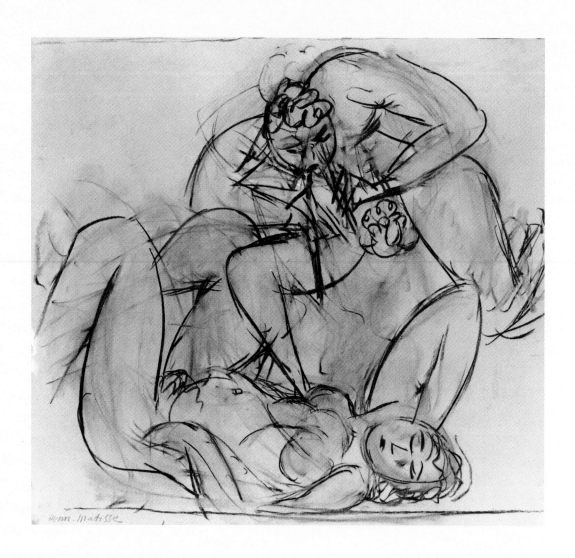

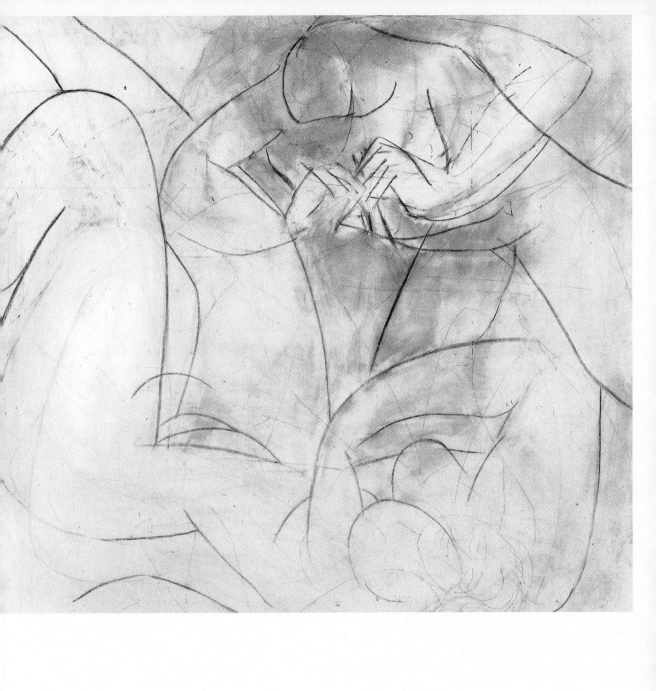

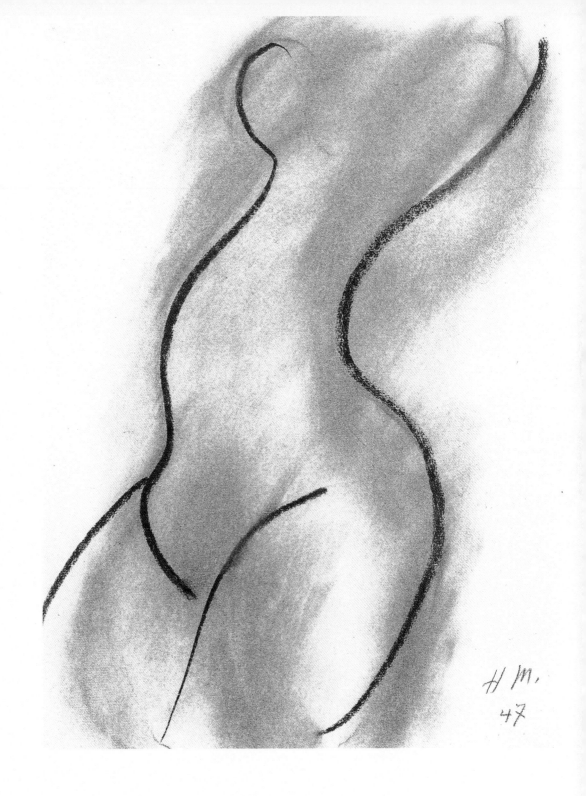

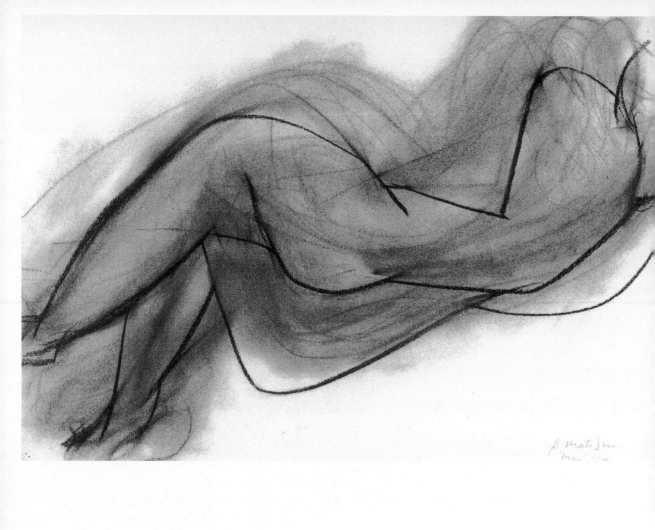

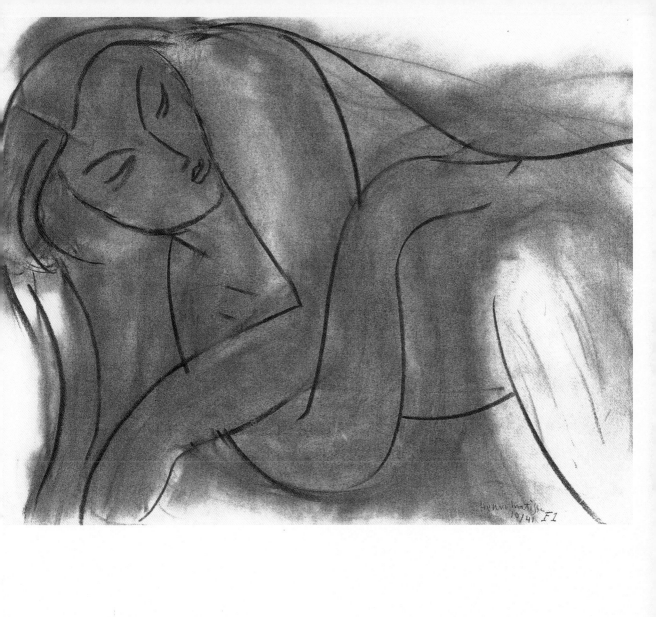

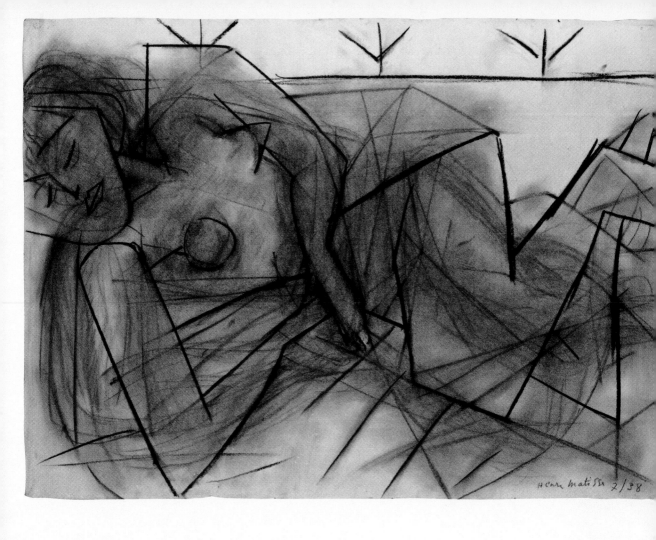

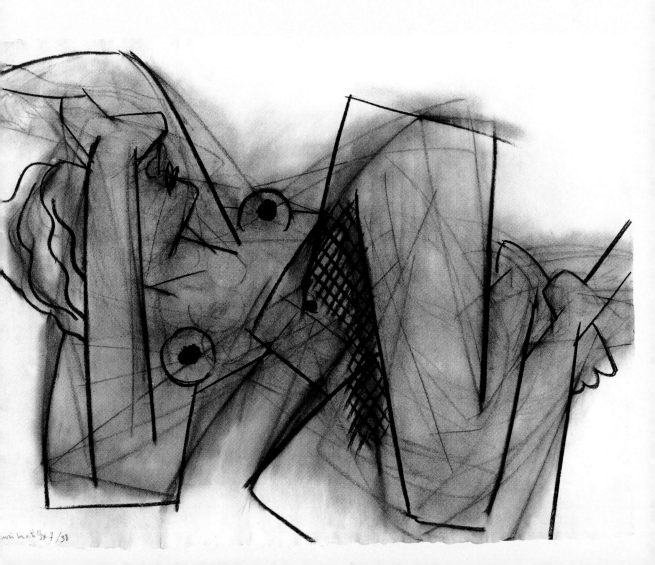

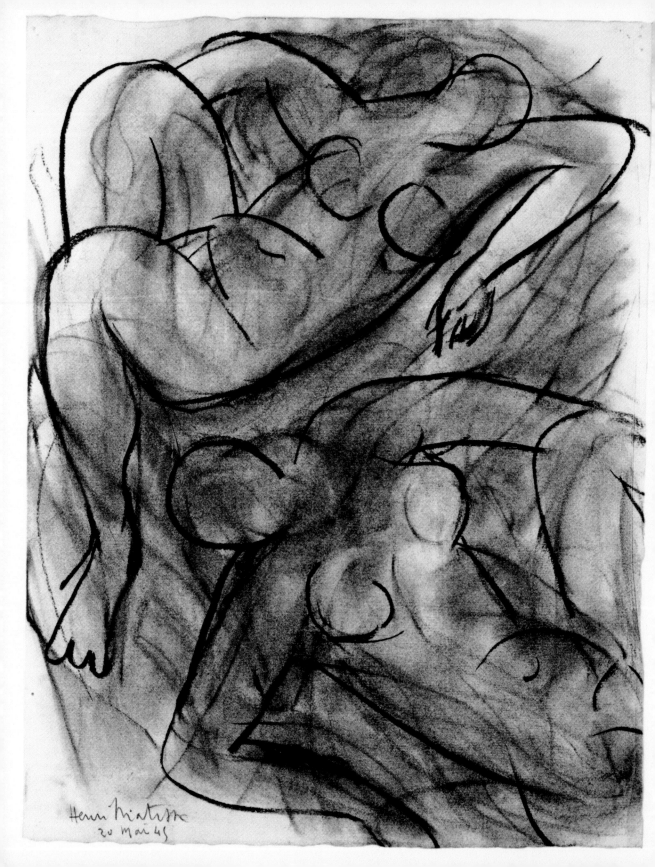

HENRI MATISSE
Erotic Sketches

Norbert Wolf

Everything I have ever done, I have done out of passion.

In 1932, Henri Matisse (1869–1954), in conversation with the 36-year-old surrealist André Masson, listened to the younger artist explaining his method of working. Masson described how, in the course of the creative process, he would first make abstract, abbreviated sketches on paper or canvas and then rework them to incorporate concrete traces of his memories of figures or objects. "How strange," remarked Matisse, "I do exactly the opposite. I always start with something – a chair, a table – but as I continue working, I become less and less aware of it. In the end, I can barely remember the subject matter I started with."

Table and chair can be seen as representing, *pars pro toto*, the still lifes and interiors that form such a large proportion of Matisse's output throughout every period of his career. More predominant still among the paintings, drawings, prints, cut-outs and sculptures of this outstanding artist, however, is the female body, both clothed and, rather more often, nude.

For many years, the art of Henri Matisse was dismissed as little more than an exercise in hedonism – the indulgent whim of a bourgeois artist comfortably ensconced in the realms of conventional decorative beauty, utterly untroubled by the fact that Europe was lurching from one catastrophe to the next. Today, however, Matisse is deservedly recognised as the artist who, together with Picasso, laid the compositional foundations of modern twentieth century art. But whereas Picasso did so through the destruction of forms, Matisse did so through the construction of an innovative visual texture of colour and rhythm in

the spirit of Cézanne. "What I dream of is an art of balance, of purity and serenity, devoid of troubling or depressing subject matter, an art that could be for every mental worker, for the businessman as well as the man of letters, for example, a soothing, calming influence on the mind, something like a good armchair that provides relaxation from fatigue."

Yet Matisse's modernity – verging on abstraction without ever completely abandoning the figurative; the flatness of image, the autonomy of colour – certainly did sit back and relax in the comfortable 'armchair' of an art aimed at appealing to some superficial passing fashion. Matisse did not deploy the decorative arabesque for its own sake, but used its elegant form to veil a complex and ambiguous approach. What role did his portrayal of the feminine, and most especially the female nude, play in all of this? Was he also applying his process of 'disremembering' the subject matter here?

Indeed he was. If we compare Matisse's nudes to the sketches and drawings of nudes by Rodin, Klimt, Schiele, Kokoschka, Picasso, it is striking how much less 'direct' they are. These are not close-up encounters with sexuality and desire, nor do they subscribe to any provocative *chronique scandaleuse*. With a lightness verging on weightlessness, Matisse conveys an iconic visualisation of the beautiful 'object' that is the naked female body without the slightest soupcon of pornographic revelation.

The potentially voyeuristic gaze of the artist and the viewer upon the model as she poses, which conjures that unholy alliance between seeing and power and which constitutes what Marianne Karabelnik has described as the violence of the eye, has no chance to operate within Matisse's extremely reduced version of what the viewer might expect in terms of an image of physicality and nudity.

In this respect, the feminist criticism levelled at Matisse in the past on grounds that his portrayals of interiors tend to be peopled with passive female

figures, often inactive and recumbent, evidencing a 'controlling' male gaze and the intention of dominating women, is misplaced. Admittedly, those 'goddesses' of modernism that Matisse loved to portray – long-legged Eves with curvaceous thighs, ample breasts and wasp-like waists – are also representative of male desire. Yet, at the same time, they 'dematerialise' that desire in favour of an artificial aesthetic.

How are we to gauge the role reversal of the classic painter/model relationship in Matisse's own description of the model's presence as "*un viol de moi-même*" – as a 'violation', or even 'rape', of the artist? Incidentally, in his early career, the model was often a nude photo or postcard or a similar erotic illustration.

For Matisse, passion, sensuality and the expression of desire were never a matter of the individual body and its presence sketched on paper as a self-sufficient vessel of erotic powers, but the result of an all-encompassing and super ordinate visual strategy involving the integration of the respective figure into the coordinates of the picture plane and its highly charged relationship to the surrounding empty spaces. The sensuality that radiates from each of these works is generated not by erotic detail but by the brilliance of the compositional syntax. As Matisse himself put it: "'Expression' does not to me reside in the passion which will light up a face or will be translated into violent gesture. It is in the whole arrangement of my picture: the place taken up by the bodies, the spaces round them, the proportions, all play their part."

The means to this end was a purity of line redolent of the paintings of French classicist Jean Auguste Dominique Ingres (1780–1867), who Matisse held in high esteem. By giving priority to the overall composition rather than to the individual detail, such aspects as anatomical and proportional exactitude, the rendering of flesh tones or the details of the sexual characteristics become irrelevant. Instead, the female figure seems to alternate between volume and

plane, between the haptic tangibility and indefinable emptiness of the paper. As a result, the body drawn by the artist becomes part of a visual rhythm that constantly engages the admiring and astonished viewer. How consummately Matisse succeeds in making these pared-down, radically abbreviated bodies positively ooze sensuality; these are bodies that are entirely at one with themselves and their surroundings (as in the orientalist *odalisque* portrayals), while at the same timing serving the interests of an artistic experiment in form and composition.

In this respect, it is interesting to note what Matisse himself said of these 'ladies of the harem': "I paint odalisques in order to paint the nude. Otherwise, how is the nude to be painted without being artificial? But also I saw they exist. I was in Morocco. I saw them." No less significant is what he remarked about his studio models in general: "I often keep those girls several years, until interest is exhausted. My plastic signs probably express their souls (a word I dislike) which interests me subconsciously, or what else? Their forms are not always perfect, but they are always expressive. The emotional interest aroused in me by them does not necessarily appear particularly in the representation of their bodies, it is often, rather, in the lines by special values distributed over the whole canvas or paper, forming the orchestration or architecture. But not everyone sees this. It may be sublimated voluptuousness, and that may not be yet visible to everyone."

Lydia Delektorskaja, who was initially employed by Matisse in 1935 as his assistant and who went on to sit for him as model on a daily basis for four years, wrote a book about the remarkable relationship between Matisse and the women in his studio. It includes a telling anecdote in which Lydia asks a distinctly tense Matisse whether he is just as excited about painting a fig leaf as he is about drawing a nude, to which he laconically replies: "Yes, exactly."

The anecdote gives an insight into the eroticism of the painterly process as such, in much the same way as the "*viol de moi-même*" mentioned above – that potent energy by which the model, in whatever form, 'rapes' the artist. Matisse sought to translate this energy into its artistic equivalent. This explains why the erotic fascination of his drawings and paintings is not generated by the mere fact that the viewer sees "an identifiably naked body that arouses desire, but because we see the physical attraction completely transposed into another, artificial … order." (Gottfried Boehm)

On the path to artificial order, Matisse used photography as a catalyst, the importance of which cannot be overestimated. Some have even attributed a cathartic quality to photography, for it freed the artist from the iconographic and stylistic heritage (and ballast), and provided a new and a-historical source of inspiration. Even where nude photographs emulated the exotic and orientalist themes of the nineteenth century, they did so in a version that was updated and adapted to the early twentieth century. These black-and-white nudes provided Matisse with 'neutral' material and even, as it were, with 'negatives' that he could easily flesh out with the 'positives' of his own visual imaginings. Ideas and concepts which, even when they were derived from the exotic motif of the *odalisque* in the harem, avoided all that was merely anecdotal.

Matisse often channelled the inspiration of the two-dimensional photographic images into his sculptures which he then also transformed into two-dimensional pictures (in which the sculptures, in turn, often feature). The result: on the one hand, the formal composition – that is to say, the transformation wrought by Matisse in this process of visual alchemy – neutralises the eroticism implicit in the subject matter while, at the same time, the subject matter itself imbues the form, increasingly abstract as it may be, with eroticism.

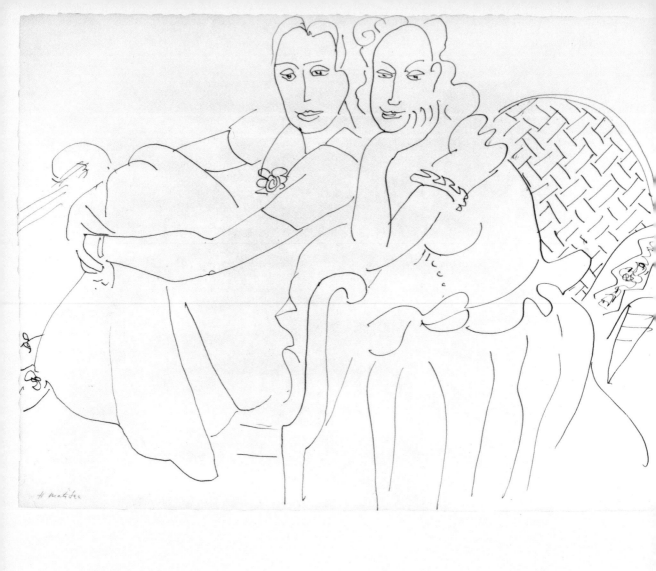

Henri Matisse
Erotische Zeichnungen

Norbert Wolf

»Alles, was ich gemacht habe, habe ich aus Leidenschaft gemacht.«

Im Jahr 1932 fand ein Gespräch zwischen dem damals 36jährigen Surrealisten André Masson und dem wesentlich älteren Henri Matisse (1869–1954) statt. Masson erklärte, er überarbeite in seinem gewohnten kreativen Procedere die abstrakten Kürzel, die er spontan aufs Papier oder die Leinwand gesetzt habe, mit konkretisierenden Erinnerungsspuren an Figuren oder Gegenstände. Darauf Matisse: »Das ist sonderbar. Bei mir ist es genau umgekehrt. Ich fange immer mit etwas an – einem Stuhl, einem Tisch –, wenn ich aber weiterarbeite, wird es mir immer weniger bewusst. Am Ende ist mir das Sujet, mit dem ich angefangen habe, kaum noch gegenwärtig.«

Tisch und Stuhl sind als *pars pro toto* zu verstehen für jene Stillleben und Interieurs, die einen Großteil des Matisse'schen Werks durch alle Schaffens-experimente hindurch ausmachen. Mehr noch aber beherrscht der weibliche Körper, der bekleidete und vor allem der nackte, motivisch die Gemälde, Zeichnungen, Grafiken, Papierschnitte, wie die Skulpturen.

Lange Zeit hat man die Kunst von Matisse als Hedonismus abgewertet, als bürgerliche Saturiertheit, die es sich im Reich dekorativer Schönheit bequem gemacht habe, unbekümmert um Europa, das politisch von einer Katastrophe in die andere taumelte. Mittlerweile gilt Matisse zu Recht als derjenige, der zusammen mit Picasso die formalen Grundlagen des modernen Bildes im 20. Jahrhundert gelegt hat. Wo der Spanier Formen zertrümmerte, baute der Franzose – in der Nachfolge Cézannes – eine innovative Bildtextur aus Farben

und Rhythmen auf. »Ich träume von einer Kunst des Gleichgewichts, der Reinheit, der Ruhe […], von einer Kunst, die für jeden Geistesarbeiter, für den Geschäftsmann so gut wie für den Literaten ein Beruhigungsmittel ist, […] so etwas wie ein guter Lehnstuhl, in dem man sich von physischen Anstrengungen erholen kann.« Doch Matisses Modernität – der Hang zum Abstrahieren, ohne indes die Gegenstandsbindung gänzlich aufzugeben, die Verflächigung des Bildes, die Eigenwertigkeit des Kolorits – richtete sich keineswegs im einschläfernden »Lehnstuhl« einer auf modische Oberflächlichkeit abzielenden Kunst ein; sie bediente sich nicht der dekorativen Arabeske um ihrer selbst willen, sondern versteckte hinter der eleganten Form komplizierte und doppelbödige Strategien. Welche Rolle spielte dabei die Darstellung des Femininen, des Aktes zumal? Unterlag auch sie der von Matisse formulierten »Entgegenwärtigung« des Sujets?

Tatsächlich: Im Vergleich mit den Aktskizzen und -zeichnungen eines Rodin, Klimt, Schiele, Kokoschka, Picasso fällt auf, um wie viel weniger »direkt« sie sich geben; sie lassen sich nicht auf den »Nahkampf« mit dem Geschlechtlichen und sexuellen Begehrlichkeiten ein, sie sind kein Beitrag zu einer provozierenden *chronique scandaleuse.* Die ikonische Visualisierung des schönen »Objekts«, des entblößten Frauenleibs erweckt in ihrem zeichnerisch meist schwerelos wirkenden Duktus nicht den geringsten Verdacht pornographischer Bloßstellung.

Der potentiell voyeuristische Blick des Malers und Zeichners sowie des Betrachters angesichts des posierend dargebotenen Modells, der »die unheilvolle Allianz zwischen Sehen und Macht« thematisiert und um »die Gewalt des Auges« kreist (Marianne Karabelnik), hat keine Chance in der von Matisse realisierten Extremreduktion dessen, was der Betrachter von bildgewordener Körperlichkeit und Nacktheit eigentlich erwarten könnte. Deshalb scheint auch die frühere Kritik von feministischer Seite her verfehlt, die Matisse, weil er seine Interieurs zumeist mit passiven weiblichen Bewohnern, oft mit träge Daliegenden bevölkerte, einen »kontrollierenden« männlichen Blick, eine intendierte Verfügungsgewalt

über die Frau vorwarf. Zugeben: Jene »Göttinnen« der Moderne, die Matisse bevorzugt in Szene setzte, jene Evas mit langen Beinen, runden Schenkeln, vollen Brüsten über der Wespentaille, repräsentieren auch männliches Begehren – aber sie »entstofflichen« es im selben Augenblick zugunsten artifizieller Ästhetik.

Wie lässt sich hier die von Matisse selbst beschriebene Umkehrung der klassischen Maler-Modell-Beziehung einordnen: jener Rollentausch, den er als »un viol de moi-même« bezeichnet – als »Vergewaltigung« des Künstlers durch die Anwesenheit seines Modells (wobei als »Modell« in frühen Schaffensphasen durchaus auch Aktfotos, Aktpostkarten und ähnliche Vorlagen aus der erotischen Bildindustrie dienen konnten)?

Leidenschaft, Sinnlichkeit, Ausdruck von begehrlichen Affekten war für Matisse nie eine Sache des einzelnen Körpers und seiner auf dem Blatt Papier hinskizzierten Präsenz als selbstgenügsames Gefäß erotischer Kräfte, sondern Resultat einer übergreifenden und übergeordneten Bildstrategie: nämlich der Integration der jeweiligen Figur in das Koordinatensystem der Bildfläche, ihrer spannungsvollen Beziehung zu den sie umgebenden Leerräumen. Die Sinnlichkeit, die aus jedem dieser Blätter entgegenstrahlt, ist das Ergebnis nicht des erotischen Details, sondern einer genialen kompositorischen Syntax. Mit Matisses eigenen Worten: »Der Ausdruck liegt für mich nicht in der Leidenschaft, die etwa auf einem Gesicht erschiene und die sich in einer heftigen Bewegung ausdrücken würde. Er liegt in der ganzen Anlage eines Bildes: der Platz, den die Körper einnehmen, die sie umgebenden, leeren Räume, die Proportionen, das alles hat daran teil.« Die an den von Matisse überaus geschätzten französischen Klassizisten Jean Auguste Dominique Ingres (1780–1867) zurückerinnernde Reinheit der Linienführung diente diesem Ziel.

Besagter Vorrang des Ganzen vor dem Singulären degradiert in den Aktdarstellungen die anatomische oder proportionale Stimmigkeit, die Charterisierung des Inkarnats, die Detaillierung der Geschlechtsmerkmale zur unwichti-

gen Größe. Der weibliche Körper schwankt stattdessen zwischen den Kategorien von Volumen und Fläche, von taktiler Greifbarkeit und indefiniter Leere des Papiergrundes. Der gezeichnete Leib erweist sich als Element einer Bildrhythmik, die den Betrachter stets aufs Neue in Bewunderung – und Staunen – versetzt: Wie viel Sensualität vermag doch Matisse aus den zu Kürzeln vereinfachten Körpern strömen zu lassen, Körper, die ebenso sich selbst gehören und ihrem »Milieu« (etwa in den orientalisierenden Odalisken-Darstellungen) wie sie dem künstlerischen Formexperiment dienen!

Bezeichnend genug die Problematik, die Matisse hinsichtlich seiner »Haremsdamen« zu bedenken gibt: »Ich male Odalisken, um Akte zu malen. Aber wie soll man Akte malen, ohne dass sie Attrappen werden? Schließlich weiß ich ja, dass sie existieren. Ich war in Marokko. Ich habe sie gesehen.« Und bezeichnend, was Matisse ganz generell zu seinen Atelier-Modellen anmerkt: »Ich behalte diese jungen Mädchen häufig über mehrere Jahre, bis sich mein Interesse an ihnen erschöpft hat. Meine malerischen Zeichen drücken möglicherweise ihren Seelenzustand aus (ein Wort, das ich überhaupt nicht mag), für den ich mich unbewusst interessiere, oder wofür sonst? Das gefühlsbetonte Interesse, das sie in mir auslösen, zeigt sich nicht in der Darstellung ihrer Körper, sondern meist an den Linien oder ihrer räumlichen Positionierung, denn sie breiten sich über die ganze Leinwand oder das Papier aus und bilden dadurch seine Orchestrierung [...]. Es ist vielleicht die sublimierte Wollust, und die ist nicht für jedermann wahrnehmbar.« Lydia Delektorskaja, die 1935 zunächst als Assistentin von Matisse eingestellt wurde, um schließlich vier Jahre lang für ihn täglich Modell zu stehen, hat über die ganz eigene Beziehung zwischen Matisse und den Frauen in seinem Atelier ein Buch geschrieben. Darin findet sich der bezeichnende Passus, in dem der hochgradig angespannte Matisse auf Lydias Frage, ob er genauso aufgeregt sei, wenn er ein Feigenblatt male wie wenn er einen Akt zeichne, antwortete: »Ja, genauso«.

Die in dem zitierten Passus zum Ausdruck kommende Erotisierung des malerischen Vorgangs an sich gehorcht eben jenem »viol de moi-même«, jenem »vergewaltigenden« Kraftstrom, den die – wie auch immer beschaffenen – Modelle auf den Maler ausübten. Ihn suchte Matisse in künstlerische Äquivalente zu übersetzen. Deshalb auch stellt sich die erotische Faszination für den Betrachter seiner einschlägigen Zeichnungen und Bilder nicht deshalb ein, »weil hier ein nackter, das Begehren weckender Körper zu identifizieren wäre, sondern weil wir den körperlichen Reiz völlig übersetzt sehen in eine ganz andere, artifizielle [...] Ordnung. [...]« (Gottfried Boehm)

Auf dem Weg zur artifiziellen Ordnung übertrug Matisse der Fotografie die Aufgabe eines Katalysators, den man gar nicht hoch genug einschätzen kann. Man hat sogar von einer Reinigungsfunktion der Fotografie gesprochen, da sie dem Künstler einen vom ikonografischen sowie stilistischen Erbe (und Ballast!) befreiten, einen gleichsam ahistorischen Fundus zur anregenden Verfügung stellte. Auch dort, wo die Nacktfotos »exotische« und orientalisierende Motive des 19. Jahrhunderts rekapitulierten, taten sie dies ja doch in einer dem frühen 20. Jahrhundert angepassten, aktualisierten Version. Die Schwarzweiß-Akte boten Matisse »neutrale« Vorlagen, offerierten sozusagen – das Wortspiel sei erlaubt – »Negative«, die er bequem mit den »Positiven« seiner eigenen Bild-Vorstellungen füllen konnte; Ideen und Konzepte, die allem bloß Anekdotischen misstrauten.

Matisse pflegte häufig die zweidimensionalen photographischen Anregungen in Skulpturen umzusetzen und diese dann zu Flächenbildern zu transformieren (in denen andererseits jene Plastiken oft wiederum als Motive vorkommen). Das Ergebnis: Zum einen neutralisiert die formale Gestaltung, also die Veränderung, die Matisse in diesem bild-alchimistischen Prozess unternimmt, die dem Sujet implizite Erotik, gleichzeitig erotisiert das Motiv die Form, selbst dort, wo Letztere sich zunehmend abstrakter gibt!

List of Works Illustrated / Verzeichnis der abgebildeten Werke

1 *Young Reposing Female* / Junge liegende Frau, 1920, pen and ink on paper, 28.2 x 38.6 cm, private collection

2 *Reposing Female Nude with Large Leaves* / Auf dem Rücken liegender Akt mit großen Blättern, 1936, charcoal, 28.2 x 38.6 cm, private collection

3 *Seated Nude* / Sitzender Akt, 1906, pastel and gouache on paper, 73 x 51 cm, private collection

4 *Marquet painting a nude* / Marquet, einen Akt malend, undated, oil on paper, 31 x 24 cm, Centre Georges Pompidou, Collection du Musée national d'art moderne, Paris

5 *Faun and Nymph* / Faun und Nymphe, 1907, pen and ink, 9.5 x 11 cm, Museum Folkwang, Essen

6 *Reposing Odalisque in turkish pandaloon* / Liegende Odaliske, türkische Hose, 1920–21, pen and ink, 28 x 39 cm, Centre Georges Pompidou, Collection du Musée national d'art moderne, Paris

7 *Untitled* / Ohne Titel, 1921–22, pen and ink, 25,4 x 31,5 cm, Centre Georges Pompidou, Collection du Musée national d'art moderne, Paris

8 *The Three Friends* / Die drei Freundinnen, 1928, pen and ink on paper, 37.45 x 50.3 cm, Centre Georges Pompidou, Collection du Musée national d'art moderne, Paris

9 *Cloaked Legs* / Verhüllte Beine, c. 1928, pen and ink on paper, 27.6 x 36.9 cm, private collection

10 *Two Women Playing Draughts* / Zwei Frauen beim Damespiel, 1928, pen and ink, 32.5 x 50 cm, private collection

11 *Two Models* / Zwei Modelle, undated, pencil, Archives Matisse, Paris

12 *The Artist and his Model* / Der Künstler und sein Modell, 1937, pencil, 25.5 x 33.5 cm, private collection

13 *Two Women Playing Draughts* / Zwei Frauen beim Damespiel, 1928, pencil, 32.9 x 59 cm, Musée Matisse, Nice

14 *Reposing Female Nude* / Liegende Frau auf einem Bett, 1929, pen and ink, 48.1 x 68.1 cm, private collection

15 *Female Nude seated in a Chair* / Akt in einem Sessel, 1927, pen and ink, 23.5 x 29.5 cm, private collection

16 *Reposing Female Nude* / Liegender Akt, 1928–29, pen and ink, 49 x 68 cm, Archives Matisse, Paris

17 *Odalisque (Sleeping Female with Chessboard)* / Odaliske (Schlafende und Schachbrett), 1928, pencil on paper, 32.7 x 50.7 cm, private collection

18 *Kneeling Female Nude* / Kniender Akt, 1936, pen and ink, 66.5 x 38.2 cm, Musée d'art Moderne de la Ville de Paris, Paris

19 *Two Seated Female Nudes* / Zwei Sitzende, 1928, pencil, 37.8 x 50.5 cm, private collection

20 *Untitled* / Ohne Titel, 1930–31, pen and ink, 28 x 21.6 cm, Centre Georges Pompidou, Collection du Musée national d'art moderne, Paris

21 *Reposing Female Nude* / Liegender weiblicher Akt, 1935, pen and ink on paper, 45 x 56 cm, The State Hermitage Museum, St. Petersburg